returning the sword to the stone

returning the sword to the stone

mark leidner

Fonograf Editions

Fonograf Editions
Portland, OR

First Edition, First Printing

FONO10

Published by Fonograf Editions
fonografeditions.com

For information about permission to reuse any material from this
book, please contact Fonograf Ed. at fonografeditions@gmail.com.

Distributed by Small Press Distributions
SPDBooks.org

ISBN: 978-1-7344566-3-9

LCCN: 2020949708

CONTENTS

Prism Jugglers / 3

The Truth about Wizards / 5

Volunteering / 6

Returning the Sword to the Stone / 13

Eight Things I Hate about Me / 28

Youth Is a Fugitive / 31

Having "Having a Coke with You" with You / 34

Being with You / 36

Salad on the Wind / 44

Opening Day / 54

I'm Running for President / 55

Spoonerisms / 60

Plague Blessing / 68

Church / 71

Love Is a Waveform / 72

The Jeansed Horse / 74

Humility / 80

PRISM JUGGLERS

Handcuffed skeletons washed ashore.

We walked in sandals of cantaloupe rinds.

We wore newspaper fedoras.

We anointed stars the source of our laws.

We drained cocktails across the sea

through really long straws.

We hid live doves in hollowed-out Bibles.

We shot cannonballs point-blank into gongs.

We juggled prisms, as you know.

We were roosters paid not to crow.

We binge-watched sitcoms set in sweatshops.

We finger-painted our own Rorschach inkblots.

We blinded each other by bouncing the sun

off our meat cleavers. We played pianos

whose keys were upturned human fingers.

We shook human hair pompoms at the fuckless moon.

With poems in Sharpie on water balloon

we bombed the doomed.

Our stovepipe hats prevented dementia.

Our bowling shoes prevented mildew.

Our clown shoes prevented hubris.

Our crowns of thorns prevented déjà vu.

THE TRUTH ABOUT WIZARDS

A lot of books recently have been written about how magic is real and some children are born with its powers. In such stories, they only need to be whisked off to some magic academy and trained to use those powers. Then, after a few quaint tribulations, they're heroes. Then they live on as wizards in a magical world, or as wizards masquerading as normal people in an unmagical reality, perhaps using magic here and there to save either the real world or the wizard world, but always from something at least as equally magical, but evil.

If you happen to be a fan of such stories, I'm sorry. That's not at all how it works. In the real world, everyone is a wizard without knowing it, and all children attend wizard academies without being told that's what they are, and there is no big unveiling where you finally learn you're a wizard and start doing magic. You just never find that out. You're raised by wizard parents who you don't know are wizards, you attend a wizard school that you don't know is for wizards, and everything you learn is magic but you do not recognize it as such. You live your whole life as a wizard who does not know they are a wizard in possession of powers you do not recognize as magic. The moment you believe you can actually do magic or that magic is real, you are kicked out of wizard school and your powers are stripped, and you're forced to live the rest of your life knowing magic is real, but that you are not a wizard anymore, and that all the other people who don't know magic is real remain real wizards.

VOLUNTEERING

There was this duty they needed somebody to volunteer for

something of no apparent use to anyone

and it was also clear

that I was the one who everyone expected to do it

because everyone else had paid their dues

but I was new and hadn't volunteered for anything yet

and so as they were going around the room

asking us if we wanted to volunteer

I wasn't sure what I was going to do

cave in to the pressure, or protect my time.

Honestly, I was leaning toward volunteering

thinking that working my way into their good graces

might get me out of some real work somewhere down the way

and I had almost decided to volunteer on that basis

when all their eyes landed on me.

They just kept staring at me

waiting for me to volunteer

knowing I would if only they could wait me out

and I lifted my hand as if I were about to

only to draw it back down in one smooth motion

pretending to scratch my other arm

as if I were an idiot

who didn't even know how to just sit there

without giving the false impression of imminent speech

or action. It was a total letdown

to everyone else in the room

and I could feel our morale beginning to crumble

around me like invisible pillars.

Eventually the meeting agenda moved on

and there I sat in a reverie of self-congratulation

having successfully evaded yet another of their attempts

to guilt trip one of us into wiling away precious hours of our lives

in pursuit of an objective they claimed was indispensable

yet refused to make mandatory—

a policy that to me belied

that the duty had nothing to do with the duty itself

and everything to do with them wanting us

to seem as self-sacrificially busy as possible

which was the opposite of what we all actually were

which was doing the bare minimum necessary

to maintain the standard of living a thousand times greater

than everyone else on the planet to which we felt entitled—

and then, for the first time that morning, I had an epiphany

I hadn't had before:

that even if one never volunteered for anything

by virtue of merely having attended these meetings

one was volunteering to bear witness to the sacrifice

of hours offered by anyone else who raised their hand,

enough participation in the ritual for me to feel complicit

if not in the offering itself, then in its sanctification

and I felt a great emptiness well within me then

there at the conference table, as if this epiphany

rather than being added to my wisdom

had been subtracted from my dignity

and then a new and even more unpalatable viewpoint

cobbled itself together in the fog of my mind

as the meeting coursed on—something about

the supreme hypocrisy of taking pleasure

in resisting the enterprises of an organization

I clearly despised, yet clearly not enough

to simply leave and move on with my life

and in that moment I knew I was a coward and a parasite

who would've weaseled out of any duty

whether farce or noble, whether the solipsistic

circle-jerk of a privileged elite, or a beautiful act

undertaken in service of a universal humanity—

and I hung my head in shame and self-admonishment

there at the conference table, the rictus quake

of a conscience that had tried and failed

one too many times to wake—

but then, just as suddenly, I swung my head back up—

I'd known this about myself all along

had worked for years, in fact, to insinuate myself

into the folds of this organization, not for the money

like everyone else, but so the dead weight

that I would've added to any whole of which I was a part

would be borne by that which ought to atrophy

and spared from that which ought to flourish

and it was on the crest of this wave

of heroic self-contempt

that I mentally coasted through to the end of the meeting.

But then at the end of the meeting

they brought the whole thing back up again

asking someone to please volunteer

and looking straight at me when they did.

By now, I was feeling cocky

and decided to speak. "Look," I said.

"Normally, I would volunteer.

It's just that right now I can't.

I have a million other things to do."

This was secretly hilarious to me

and secretly infuriating to everyone else in the room

most of whom really did have a million things to do

and all of whom knew that of everyone there

I had the least to do.

But in behavior typical of these sorts of meetings

no one had the temerity to point that out

so I just stared back at them

like they were a distance I was refusing to enter

then it switched and I became the distance

they were staring into and refusing to enter.

The face-off lasted for what felt like forever

though in reality it was probably less than a minute.

Eventually, a hand went up in the back of the room.

It was one of those people who really did

have a million other things to do, volunteering.

RETURNING THE SWORD TO THE STONE

It's like Sisyphus making direct eye contact with you while sarcastically kissing and licking the boulder.

It's like picking up someone for a date in a bulldozer you drove straight from a construction site while still pushing a load of scrap metal forward.

You run up an escalator so forcefully, your feet throw the metal tread in reverse, and the whole mall goes back in time.

It's like chasing a runaway red wagon full of priceless porcelain artifacts down an endlessly spiraling stone staircase.

It's like drying your hand by doing the sign of the cross several times really fast.

It's like getting chased by velociraptors wearing turtlenecks and yin-yang necklaces, and the yin-yang necklaces are bouncing up and down on the outsides of their turtlenecks.

It's like sinking ever deeper into the center of an underinflated bouncy castle you tried to parkour off of.

It's like a hideous dreamcatcher made by someone who has never had a nightmare.

It's a curse called the wereperson where, every full moon, after a gory and agonizing non-transformation, you remain who you are.

It's like promising to pray for someone technically counting as having already said a prayer.

It's like God gluing pictures of fish to pictures of water and pictures of animals to pictures of land and balling it up and throwing it at a star.

It's like someone suing you because you've asked a question to which the answer is so obviously no, they shake their head so hard they break their neck.

It's like being on the beach and seeing a wave form a hand of water
that shoots you a bird before crashing down into foam. You
frown at the surf in disbelief, only for it to happen again with
the very next wave. You stare at the same spot, waiting to see if
it happens a third time, but that was it. Years later, telling the
story, you stood there all day long, and the sea had flipped you
off with every wave.

You close your eyes as the shadow you, whose eyes are on the
backs of your eyelids, opens theirs on you.

It's like a different episode of your favorite TV show on in every
room of a mansion with as many rooms as the show has episodes.

It's like finally giving up the intel in an eerily perfect impression of your interrogator.

It's like humiliating yourself in a way that neither advances plot nor reveals character.

You wake from a dream but the dream just jumps into somebody else's head and continues.

It's like whipping yourself with Christmas lights.

It's like slow-dancing to The Star-Spangled Banner.

It's like, every hour, flipping over an hourglass full of cat litter.

It's like a password you have to remember but that gives you no access to anything.

It's like a pool where the lifeguards have rifles and they shoot whoever's drowning.

It's like a mirage whose edges you must meticulously prune with fingernail clippers.

It's like a Revolutionary War-era reboot of *Jurassic Park* featuring velociraptors in full British redcoat regalia.

It's like, right before you die, a 30-second ad you can't skip.

It's like a stork that brings you a job.

It's like stepping slowly toward an icicle-sabered cavern mouth at
the base of impassable mountains.

You get caught by a giant who traps you in a jar—and you must
mock the giant by constantly doing yoga in the jar.

You have to slurp muddy water from an enormous roadside
puddle until its diameter shrinks to the size of a coin.

It's like robbing a bank with a crème brûlée torch.

It's like kudzu pulling down a Ferris wheel.

It's like cracking your tooth on a black hole baked into a muffin
and then getting sucked tooth-first through the hole.

It's like novelty nuclear ordnance whose mushroom clouds form familiar celebrity silhouettes.

You must be almost incapacitated by grief but not quite; you must acquire a glass scabbard and weep into it until it's full, and then sheathe it in a bank of snow overnight, and then after standing watch all night, retrieve it in the morning and shatter the glass with a stone—to forge a blade of sadness.

You have to pity the childhoods of those whose adulthoods you envy.

It's like porn with everything but the eyes photoshopped out.

It's like an open coffin full of complimentary muffins in the foyer of a funeral home.

It's like people wagging hotdogs at each other—while only watching their own hotdog, hoping that it doesn't break.

It's like removing royalty from your bloodline by returning the sword to the stone.

It's like an unsent love letter written in labyrinthine legalese.

It's like a life-size styrofoam statue of David blown away by a breeze.

It's like praying for enough suffering to obliterate the comfort obstructing your moral improvement, but not so much suffering that you lose all hope and no longer care about anything.

It's like a haunted lake in which the wind can spell whatever words it wants in the ripples, but it never really wants to.

It's like a magic mirror that only shows you how you're imagined by those who miss you.

EIGHT THINGS I HATE ABOUT ME

I hate it when I spend my life

breeding and training elite sled dogs

only to end up the crusty, old villain

in some younger musher's story.

I hate it when I'm giving an academic talk

at my alma mater

and my old mentor is a no-show

causing me to question the value of my scholarship.

I hate it when I humiliate a nerd

in the lunchroom or bathroom

only for them to become cool later

humiliating me at a house party or a school dance.

I hate it when I'm trying to avoid

seeing a dive bar right behind me

just as the last city bus barrels by

in the rain, reflecting in its strip of moving windows

the dive bar's neon signage.

I hate it when I spend my youth

decrying the hypocrisies of adults

only to become one

who conceives of hypocrisy

as the very pinion of consciousness.

I hate it when I plant a kiss on each bicep

in a dive bar, mocking a dockworker

with biceps twice mine in diameter

into arm-wrestling me, only to be

all the more humiliated when I lose.

I hate it when I fall off my yacht

and the weight of all the mobile gaming

consoles in my cargo shorts pockets

pins me to the seafloor.

I hate it when I'm in geometry class

intent on disrupting the lesson

with inane and off-topic contributions

only to be moved to silence

by the beauty of the Pythagorean theorem.

YOUTH IS A FUGITIVE

that thinks it's a hostage.

You know the labyrinth has two exits

if you can feel the wind.

Hell is an orgy of everyone you know

heaven an orgy of strangers.

Just the faint glimmer of

the possibility of love

instantly gerrymanders your entire past.

An exotic analogy to which no one relates

but to which people wished they related

will always outcirculate an actually apt

analogy to which people actually relate.

A child surprised that a neon sign

isn't hot the first time they touch one

knows how it feels as an adult to achieve one's goals.

The amount of muffin left stuck to the wrapper

when you open it

is the percent of your childhood

that was the way you remember it.

Crime is a dream justice has when it sleeps.

Boredom is the cruelest aphrodisiac.

All you need is love

to have a home in every moment

and all you need is poetry

to have it be a mansion.

Desire rudders a ghost ship.

Believing in God is like believing

in an endless stream of letters following Z.

Loving anything more than yourself

is like a misquote that clears you of plagiarism.

Cowardice is the fear of suffering

courage the fear of wrongdoing.

Nothing is purer than gratitude

and because it's so pure

it's the first thing to blow away when the wind blows.

Anything is possible

but everything is too expensive.

History is stranger than truth or fiction.

The eyes are teeth that see.

Grace is a diaper you never have to change.

Morning, a more convincing dream.

Life is long for a brief time

then brief for a long time.

The problem with irony

is that it is too soothing.

It suggests a pattern to tragedy

and therefore mitigates the terror that tragedy is random.

Were tragedy patternless, we'd be meaningless

and all the ironies of literature are a dam against this despair.

HAVING "HAVING A COKE WITH YOU" WITH YOU

You asked me if I knew the poem "Having a Coke with You"

I said I vaguely remembered it but didn't really

and then you recited it in its entirety as we were walking

from somewhere up by City Hall down to South Street

and the whole time you were reciting it I was thinking

"Was that the end of the poem?" after every line

and each time I thought that, I thought it more intensely

because as the poem got longer the fact that you were reciting

it from memory became increasingly harder to believe

until about halfway through the poem I stopped thinking

about how long it was and started just listening to it

which I had been, but only a little, because of all that. Anyway

then I started listening to it for real, and when you finished

I thought that that was the end of why you had done that

but as soon as you finished, you started talking about how

you used to think that that poem was just about being in love

and how being in love with someone was so wonderfully banal

but then you said that recently you thought it was more

about the futility of caring about art at all

when you could spend all that energy caring about someone

real instead, and you said that now that I'd heard it

you wanted to know where I stood if anywhere on that question

and I was as struck by the question you posed as I was

still stunned that you could recite so casually such a long

good love poem, and as well, that you hadn't even recited it

primarily to acquire appreciation for your recitation

so much as to ask what I thought about what you thought about it

now, versus how you thought about it then, and this was

when I knew I wanted to be with you forever.

BEING WITH YOU

It's like flying so first class

I don't care if we crash.

It's like becoming extremely happy

because you've found buried treasure on the beach

even though you were already happy

just from being on the beach.

It's like finally fathoming the origins of poverty

after a lifetime of studying money

then acting confidently to eradicate both

and succeeding so completely

you don't even piss off the people

profiting off the system as it is

they just bow out magnanimously

and assist you in administering your reforms.

Being with you is like getting caught in a spiderweb

but instead of being strangled by silk

before being eaten alive, the spider spins you

a gossamer throne in the center of its web

and with a sweeping motion of its terrifying feeler

offers the rest of the web as refuge

from the ills of the world

then spends the rest of its life

paying you in fresh-caught flies

for the honor of hosting you.

Being with you is like conceding an election

you didn't even really want to win

and only ran in as a favor to a friend

who really, really loves democracy

and now that your debt has been paid

you get to revel in the double pleasure

of being debt-free and never having to govern.

But not even any of this really gets at

what it's really like to be with you

but also not caring that it doesn't

is actually what it's a little bit like.

It's like being in possession of a ring

you know is enchanted without knowing what it can do.

You only know you're in a story

in which there is such a ring already on your finger

and no matter how much of the narrative elapses

you're always in that part of the tale

that exists just before the ring's history is disclosed

and so your life is lived on the edge of this feeling

that you're only ever a few pages away from

finding out how much more you suddenly matter

due to the permanent perception

of an imminent improvement

in your understanding of the power of the ring.

Being with you is like being with someone

you enjoy listening to talk about themselves

so much that you find yourself forgetting

everything they say on purpose

so that if it ever comes up again later

you can ask them about whatever it is

and when they proceed to tell you about it

you get to hear it as if for the first time

while the feeling that you have heard it all before

also never really goes away.

Being with you is like reading poetry

written on another planet, but by the same

species we are, but a species whose history

is different from ours, and learning that although

everything is different because our histories are different

a handful of random characteristics

remains uncannily similar.

Being with you is like an echo

delayed for so long

that the original sound

is lost to history

until out of nowhere

the echo knocks you down

not in its loudness

but in how strongly it recalls

the memory of the original sound

and you marvel at the profound

relief into which it throws how far

your own identity and context have shifted

since the original sound

sounded—and how instantly

the feeling of being whoever you were

back then returns to whoever you have become

freeing you to feel how whole you are in time.

Not being with you

is like carrying around

a wound from an injury

one has never even had

the dignity

of even being given.

It aches forever—

a phantom pain

undoing the mind

and adding suffering

from which you get to reap

not even humility.

Not being with you

is like having the best song lyrics ever written

but in a universe in which there is no

melody over which to lay them.

Being with you

and not being with you

are completely oppositional

categories of being

with nothing in common between them

except what they share in comparison

to all the time before we understood

the bond our beings would one day undergo

a status which seems now unrecallable

in the same way that trying to remember where one was

just before being born is impossible—

and yet, it's like this

exactly, right now

for everyone who will ever be born someday—

how they feel now matching how

I felt before I was with you

and would feel again without you.

Being with you is like picking up a musical instrument

and being able to play it perfectly for the first time

and being so surprised by the beauty of the music

that you drop the instrument on the floor

where it shatters into thousands of pieces

and as you bend down to pick up the closest piece

you find that you're still somewhat able to play just that fragment

and although the music that that fragment makes

isn't beautiful, it does cast a spell

over all the other broken pieces

which slide across the floor, ascending to converge

around the fragment in your fingers, creating

a cracked, magical version of the original instrument

and every note the reformed instrument makes

is heretofore in the world an unheard thing

that being with you is like.

SALAD ON THE WIND

A religion that gives us heaven first.

An earthquake extending a round of roulette.

A picture of liquor that quenches your thirst.

A poem so glib you start to sweat.

A cathedral with a flesh-toned steeple.

A moonbeam caught in a slug-trail glyph.

A hotel room with a stained-glass peephole.

A shattered urinal at the base of a cliff.

A pigeon stuffed into a baby bottle.

A chihuahua asleep in a collection plate.

An all-glass casket for a supermodel.

A magnolia growing out of a sewer grate.

A salad made of dead leaves and rain.

A joke a mime breaks their silence to explain.

Shark-hunting with American flag-colored chum.

A gavel hammering a grain of sand.

A cannibal choking to death on a thumb.

An hourglass on the witness stand.

Art supplies stuffed into torpedo tubes.

A Monet frisbeed into the sea.

Mars and the moon terraformed into cubes.

A Rubix cube growing on a grapefruit tree.

A warehouse full of moldy fedoras.

A border only a moron would close.

A shark moralizing to its remoras.

A scarecrow torn by empathy for crows.

Centaurs playing kickball well.

Water boiling in the toilets of hell.

The Ten Commandments in ten different fonts.

A solar system with a dollar-sign star.

Hell with really good restaurants.

The Holy Spirit in a driverless car.

Shag carpeting on the steps of a ladder.

The privilege in which indifference is coated.

A happy song that makes you sadder.

A pill that makes you think you've voted.

Billionaires playing chicken in yachts.

Brinkmanship between a species and its niche.

Dogs playing fetch with astronauts

on the moon, and the moon on a leash.

Concrete leaves no one can rake.

A border wall around a birthday cake.

A hurdle that rises just as you jump.

The Grand Canyon leveled off with caulk.

The Statue of Liberty taking a dump.

A crossbow loaded with a celery stalk.

A magic beanstalk that scrubs CO_2.

Syringes full of Christmas tree sap.

Medical bees that sting cures into you.

An apocalypse so satisfying you clap.

Celebrities offering $15,000 hugs.

A ménage à trois between three yous.

A curse where you shrug if anyone shrugs.

A giant hourglass with a lit fuse.

A painting of heaven in a barbwire frame.

A rendezvous that leaves you the same.

Handguns smuggled in apple pies.

Salsa served in the Holy Grail.

A cat with two buttholes for eyes

and a single eye under its tail.

Fingerpainting done without joy.

Carbonated barbecue sauce in a can.

A sense of humor only privilege could destroy.

A former President living in a van.

A corporate astrologist calling in sick.

Eagle feathers stapled to a chicken wing.

Evil with nobody left to trick.

An aria only a moron could sing.

A condom stuffed with a pizza slice.

A plumbing problem in paradise.

Technophobes worshipping a crucified drone.

A painting of heaven on a bowling pin.

Beethoven butchered on a xylophone.

A coma no one can prove they're not in.

A superpower cowed by a rube.

A pseudointellect you can't turn off.

A powdered wig on a Rubix cube.

A boy band eating salad from a trough.

An 'everything bagel'-flavored scone.

Honey mustard stains on a treasure map.

Icebergs made of frozen cologne.

Amnesia in the middle of a victory lap.

An emperor lamenting the mutability of signs.

A bazooka that shoots Proust's madeleines.

A human hand reaching out of a purse.

A quart of cologne hurled over a wall.

Deodorant that makes the world smell worse.

A war memorial in a bathroom stall.

Majority shareholders mistaken for gods.

Galleries clogged with superfluous art.

A curse where you nod if anyone nods.

A cannibal choking to death on a heart.

A chessmaster choking to death on a pawn.

A mercy-torpedoing of the Great Barrier Reef.

An upside-down shopping cart trapping a swan.

The marketability of unspeakable grief.

A twinge of guilt at the end of each thought.

A pogo stick gouging a hole in one spot.

A single ghost stretched out over the entire sky.

A symbol you're paid to misperceive.

An attorney who only takes payment in pie.

A cult whose leader asks you to leave.

Pecan shell armor on a samurai roach.

An astronaut suit dredged from a lagoon.

A basketball team with a dog for a coach.

A bad dream that's a good dream that ends too soon.

A vending machine full of cowboy hats.

A bra stuffed with pages torn from the Bible.

A Supreme Court Justice exploding into bats.

A conch shell sued by the sea for libel.

A lighthouse pierced with a thousand knives.

Five thousand years of unearned high-fives.

Reality and memory connected by ferry.

IV bags full of unicorn drool.

A guillotine halving a maraschino cherry.

A pair of merpeople marooned in a pool.

A clock with two middle fingers for hands.

Planets added to the sky with cranes.

Paradoxes everyone understands.

Pools with barbwire swimming lanes.

Health insurance on the end of a hook.

A butler that runs if anyone knocks.

A spoiler alert in a history book.

A salad in a safe deposit box.

A knight parkouring in iron mail.

A fireworks exhibition in the belly of a whale.

Millions of prayers pinballing off stars.

A sexually transmitted fear of clowns.

Statues of Liberty on the moons of Mars.

Velociraptors waltzing in wedding gowns.

Misery misremembered as strength.

Miranda rights delivered in song.

Election years of infinite length.

Books banned for being too long.

A bouquet of okra in a suitor's hand.

A samurai brandishing a butter knife.

A crown of thorns on an ampersand.

A softball game that changes your life.

A dragon doing sit-ups and crunches in a cave.

A tiara on a tidal wave.

OPENING DAY

If they ever really did clone dinosaurs

and built a real Jurassic Park

it would be funny if a tiny, little

asteroid arrived

and destroyed only it.

I'M RUNNING FOR PRESIDENT

I believe every dog turd is a sundial

when the sun is out, and when the moon is out

every buffoon is a poet, and wisdom is anything

an idiot will pay to find out

no matter what heavenly body is visible

and I'm running for President.

I sew closed the neckholes of my sweatshirts

then sew beltloops along their bottom hems

and slide my legs through the sleeves

because I wear sweatshirts like pants—

and I cut the crotches out of all my sweatpants

for my head to go through

because I wear sweatpants like shirts

with my arms through the legs

and I'm running for President.

Whenever I successfully pass through a doorway

I turn around and point a wry, weary grin

at the door, and fist-bump the doorknob

like the door and I are dramatic foils

who've finally learned to work together

at the end of a buddy-cop epic—

and I'm running for President.

I believe that 'Christ' rhymes with 'fist.'

I believe babies should get braces on their baby teeth.

I believe the 'b' in 'subtle' should never be silent

and I'm running for President.

I take power naps on diaper-changing stations

in the bathrooms of casual restaurants.

I put peanut butter on both sides of one slice

and jelly on both sides of the other

and then eat the sandwich with gloves.

Out of old calendar pages, I fold

paper airplanes I then fly through the rain

less to say anything profound about time

than because calendars tend to pile up

and the paper they're made of is usually substantial enough

to cut through the wind, and to repel falling water

and I'm running for President.

I'm always marching under arching trellises

of roses not yet in bloom, producing epiphanies.

I'm always wearing sunglasses in crowded cafés

to hide my eyes because I'm crying from all the epiphanies

and when I go to the bathroom and bend down to flush

my sunglasses inevitably fall into the toilet

and when I rush out to ask the barista

to borrow some rubber gloves with which to fish them out

my pants are always still down around my ankles

and I'm running for President.

Did you know that since primordial times

certain columns of open air

were predestined to become elevator shafts?

Did you know that all the restaurant fare

in the world is secretly prepared in a single underground kitchen

and sent to every restaurant kitchen on the surface

through a network of pneumatic tubes?

Did you know that if you spread your arms out wide

and spin around really fast for a really long time

then suddenly hold your head still with your hands

you can see all of history at once?

These and more are the mysteries I store

in my mind, and that I'll be sharing even more of

with my friends—when I become President of them.

I'll sign legislation like I'm trying to find

the sea with a cinderblock

on the bottom of a glass bottom boat.

Picture a giant bowl of Caesar salad

shot out of a Civil War-era cannon:

chunks of crouton biting huge holes in the enemy's meadows

veils of topsoil thrown up to the height of the clouds

cavalry officers clotheslined by strips of romaine

these are how I'll do things in general.

Like a shadow swinging a briefcase heavy with evidence

en route to sue into oblivion the thing that casts it

in the great unbribable outdoor courtroom of the sun

I'll shoulder a golden boulder the size of the moon

through the same needle eye in the Bible

rich people aren't supposed to be able to ride camels through—

and I'm running for President.

At the dawn of my inauguration, I'll pen a permanent declaration

changing out all the diaper-changing stations

in the bathrooms of casual restaurants during Halloween

because those things are usually white

or off-white, and when you walk in

for a second they look like elongated, wall-clinging ghosts

and people are already scared enough as it is.

SPOONERISMS

let's dance

debt's lance

bent to me

meant to be

love of treasure

trove of leisure

death of retail

wreath of detail

hustled a mystery

muscled a history

found a buyer

bound a fire

car wash

war cash

pays dues

days, pews

scattered showers

shattered, scours

debt bubble

bet double

party on

arty pawn

tragic mopes

magic tropes

ballads of sadness

salads of badness

various cultures

carry us vultures

near and far

fear and noir

crackles and grows

grackles and crows

eat the flowers

fleet, the hours

boring, the meetings

mooring the beatings

looted and burned

booted and learned

popcorn

cop porn

amuse without bite

abuse without might

random tongues

tandem rungs

a platter of latitudes

a ladder of platitudes

the ways of mind

the maze of wind

a massive past

a passive mast

the iconic law

the laconic awe

of golden ages

of olden gauges

of glamorous cliffs

of clamorous glyphs

a cute stupidity

astute cupidity

sung us in the fauna

fungus in the sauna

lakes moving

makes loving

license

silence

no lore, no mess

no more, no less

fuck labels

luck, fables

habit, roles

rabbit holes

good marriages

mood garages

the rest is naked

the nest is raked

the worst of birds

the burst of words

lots to pick from

pots to lick from

a lottery for posers

a pottery for losers

reading the news

needing the ruse

the whole of rumor

the role of humor

scary prisms

prairie schisms

buffering is seeing

suffering is being

at fashion's pace

at passion's face

the nature of storms

the stature of norms

weird how stealth

steered how wealth

harried the bidden

buried the hidden

deeper by the chosen

cheaper by the dozen

verses howled

hearses, voweled

bland with fame

fanned with blame

a nailable vow

available now

shop, dine, fly

flop, shine, die

stamped under cars

camped under stars

the roof of the prison

the proof of the risen

brought to sing

sought to bring

song, but rain

wrong, but sane

brought to sake

sought to break

hung from a limb

lung from a hymn

din wowing

windowing

numinous light

luminous night

clear as day

dear as clay

to every road

to reverie, owed

a psalm to come

a calm to some

PLAGUE BLESSING

Panicked disorientation in the predawn gray.

We steep the tea three times before throwing it away.

It is certain

that every landscape vanishes into uncertainty.

It is impertinent

how therapeutic sunlight feels on the face.

The last generation to remember meeting people before the
 internet

birthing the last one to remember when strangers could touch.

The worst thing I can think of is that as long as suffering gets worse
 in the future, the suffering of the past becomes so instructive,
 you can almost be glad that it happened, since without its lessons
 the suffering to come might be unendurable, and so you almost
 crave more suffering, for if more suffering comes after that, more
 suffering before it becomes your only preparation, or possible
 salvation; and yet, if suffering doesn't worsen, if suffering relents,
 then earlier suffering becomes comparatively pointless. If suffering
 only subsides, then one would have been better off without
 suffering earlier, at all, and one is doomed, it seems then, to drag

the negative fruits of all previous suffering endlessly forward, no matter how great or how small, sullying the lessening of suffering of which a future can sometimes be made.

Every day you die a little more, but up until the moment you actually die, you're infinitely young.

"Since I am not connected to or affected by their suffering, I will go out and spend time among them." vs. "Since I am connected to and affected by their suffering, I will not go out and spend time among them."

Grief doesn't break your heart; it expands it. It breaks your brain; nature's whispered gibberish is suddenly intimate.

Every new movie you view is the sequel to the last movie you saw and the prequel to the next one you will see; one cinematic saga per person per lifetime is therefore created, curated continually with each new movie viewed no differently than a poet choosing the word that comes after the previous word and before each subsequent word until the poem is concluded.

May wisdom's sweet resplendent light sweep the darkness and pain from the plain of your striving cognition.

May the cradle of nothingness hold the wilderness of you in its
furious sway.

May you weep with the numinous delirium of those reborn who
were born before.

CHURCH

Whenever I go back to church as an adult

I gnaw a little on the pew in front of me

like I'm a beaver trapped in human form

and the wood tastes exactly the same as it did

when I was a child, and I am comforted.

LOVE IS A WAVEFORM

we want ever more of

so we pull at both ends

until it becomes a straight line.

A river finally arrives when it goes dry.

You can't have your cake and eat it too

but you can always not have it

and never eat it either.

Every poem is a list.

Every second the universe breaks

its own record for length.

The further a civilization advances

the more advanced its historians find

all past civilizations to have been.

You can't drain the ocean of lies

without a poem in which to put all the water.

You don't need a formal education to succeed

but you do need a formal education

to know you don't need one.

It's easier to get someone who has given you something

to give you everything

than it is to get someone who has given you nothing

to give you anything.

You only do anything twice

once the first time

and the second every time thereafter.

Superimposing your lifespan

over the length of a single day

falling in love would be noon

no matter how old you are.

A love you don't return is like a sunset in another country.

Waiting is a time machine.

Wait a little to see the future.

Wait a lot to see the past again.

THE JEANSED HORSE

A horse has jeans on

up to its neck

where the waistline is

tight

so its mane

remains concealed

under the seam of denim

and all the way down

to each hoof

where the cuffs

of the jeans

are also tight.

The jeans

have pockets

covering its thighs

and the pockets

carry buckets

of change.

So much change

you would think

it would be too much

to carry

but the jeansed horse

is so strong

that the change

is weightless.

The horse gallops

everywhere

huge sweat stains

soaking through the jeans

salt lines etched

like lightning in the denim.

The jeans

get grimy, taking on

the texture

of a cowboy's, the real kind

not the Hollywood

kind, all threadbare and faded and gross

but the fabric holds.

The jeansed horse prances through heaven

its big stupid meadow

of empty beauty

change shaking

in its pockets

like cosmic maracas.

Did I mention how huge

this jeansed horse is?

There's more change

in the pockets

of its jeans

than the wealth on earth. Galaxies

poof underneath its hoof-falls

like dustballs

when it thunders down out of a rear.

Black holes kick up

in its wake

as it sprints, snorts

and nebulas fire from its nostrils, leaps

clefts

between clusters of stars, etc.

A single coin

from its sail-like pockets

would flatten the sun

like a sewer access cover

flattening a grape.

What you hear

between your ears

when all is quiet

is the aggregate jingle

of all that change

shaking into itself

sound neutralizing sound

in a giant equation

in the darkness of its pockets

as the jeansed horse trots,

lopes, canters, wanders

everywhere, etc.

Knowledge lovers

hate this revelation.

When they inveigh

that this myth

appears too infrequently

in the record

to be weighed

respond with a shrug

say you want nothing

of knowledge

of the already known.

You have been to the spot

the myth began.

You have seen the sounds

birthing their words.

You have given

with your ears

the hooves of this horse

their very shoes

as the psychic lanterns

of the jeansed horse's

eyes open endlessly

on seas of sawdust darkness!

HUMILITY

Just pull it out of thin air.

Humility, I mean.

That old empty

wholeness

no one changes

without first feeling.

It's like an invisible cloak around your shoulders

you never believed was there

even though everyone you loved

and every story you adored

was trying to show you it.

It's like a beautiful vase

of an epoch and place

too ancient to name

resting on a pedestal in your foyer.

One day you throw a huge party

and the whole world comes over

and in the middle of reveling

someone elbows the pedestal

which tilts, toppling the vase

and all the guests gasp

as it strikes the floor with a clatter

but it doesn't shatter.

It just rolls there

in a weak arc

unbroken, in stark silence.

You look back up at your guests

and raise your glass

and they cheer.

You race to the vase

and pick it up.

You cradle it like a baby

and they laugh.

You hoist it overhead like a trophy

and the guests cheer again

and converge on you

and hoist you up too

as the music resumes

and you crowd-surf while holding the vase

until the vase gets passed to someone else

in the mayhem

and then that person gets passed around

shaking the vase to the sound of the music

meanwhile you get let go.

Now you're falling in slow-motion

and everything you felt

you feel again in reverse.

Contentment unmelts

into panicked paranoia.

Every blessing is cursed

and you can't believe

how afraid you've been

your whole life that the vase would break—

but if you thought it was fragile

why was it out on a pedestal?

You could have kept it in a vault

at a bank, or locked in a safe

or stuffed in a box in the closet

instead you were showing it off

a mistake you resolve not to make

again as you finally hit the floor

but unlike the vase, you do shatter.

But it's okay—

it feels awesome.

It's like a cave full of diamonds

nobody knows about

because there's a waterfall in front of it

and a jungle around the waterfall

and a desert around the jungle

and an ocean around the desert

and a shitload of nations

still stuck in a time before the invention of boats

on the other side of the ocean.

ACKNOWLEDGEMENTS

Thank you to the editors of the magazines where versions of these poems were previously published: *Cordite*, *Divine Magnet*, *The Fanzine*, *Faultlines*, *Gramma*, *jubilat*, *The Nervous Breakdown*, *New York Tyrant*, and *Pleiades*.

Thank you to the editors of Song Cave Books for publishing several of these poems in the 2019 chapbook *Salad on the Wind*.

For years of instruction, inspiration, and encouragement, thank you to Kristin Bird, Melissa Broder, Hannah Brooks-Motl, Shannon Burns, Jim Galvin, Peter Gizzi, Ally Harris, Alice Haworth-Booth, Hera Lindsay Bird, LK James, Jessica Laser, Mark Levine, Brad Liening, Alice Miller, Caryl Pagel, Zach Phillips, Emily Pettit, Rebecca Rom-Frank, Zach Savich, Rob Schlegel, Rich Smith, Jenelle Stafford, Cole Swensen, James Tate, Dara Wier, and Dean Young.

For LK James.

In memory of my parents John and Mary.

FONO
GRAƎ

A not-for-profit corporation under section 501 (c)(3) of the United States Internal Revenue Code, **Fonograf Editions** publishes literary influenced records and musically inflected books. Each release is available in multiple formats, with a particular focus on the tangible artifact. Previous titles have included *Aloha/irish trees* by Eileen Myles, *The Black Saint and the Sinnerman* by Harmony Holiday and *Live in Seattle* by Alice Notley and *Instrument/Traveler's Ode* by Dao Strom. Find a full publication list and more information about the press at: fonografeditions.com.